SILLY PUPPIES

All images found on vecteezy.com and edited using gravit.io

Copyright © 2019 Cross Haire
All rights reserved. No part of this book may be reproduced or transmitted in any form by any means, electronic or mechanical, including photocopying and recording, or by any information storage and retrieval system, without permission in writing from the author

All rights reserved.

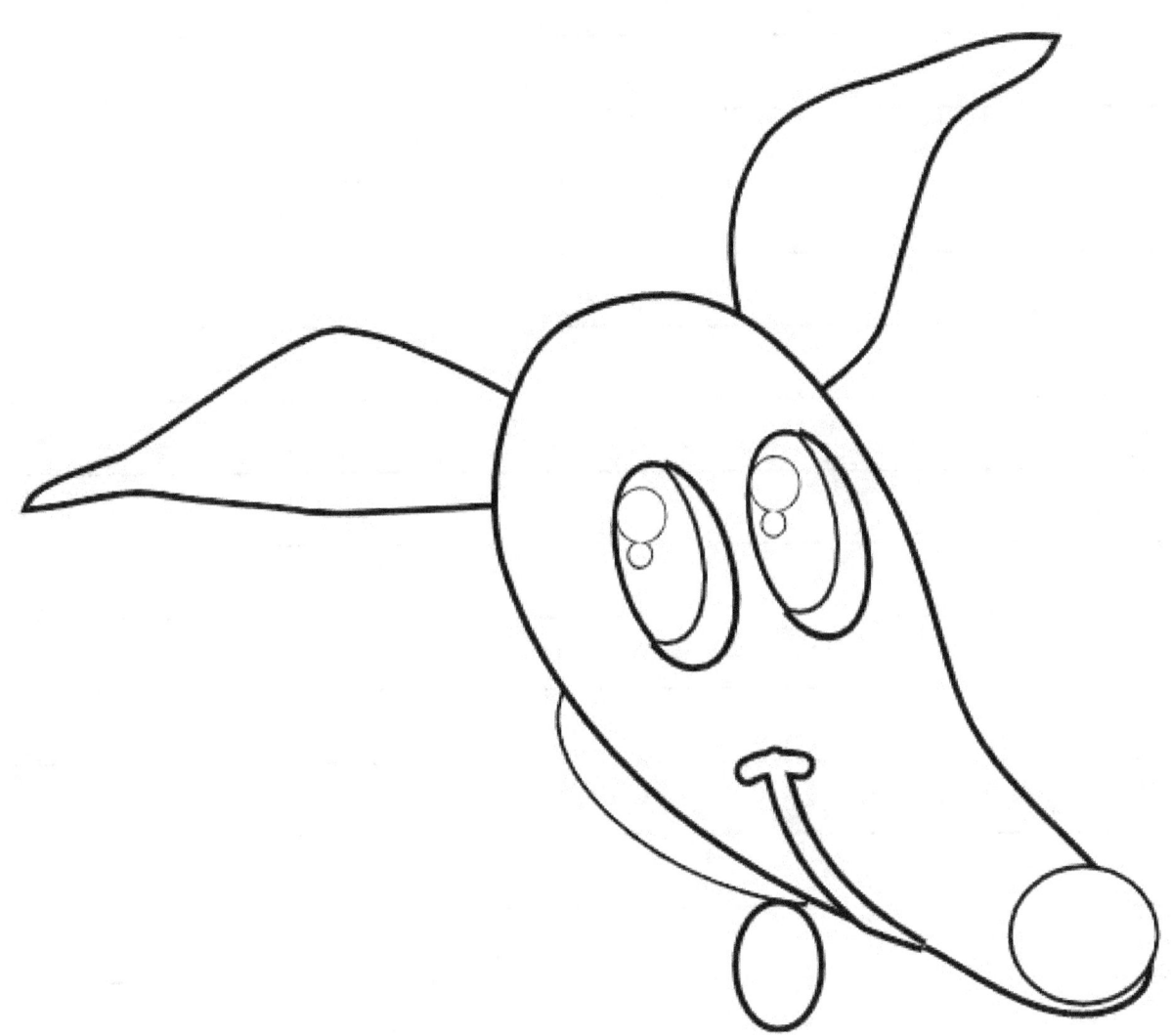

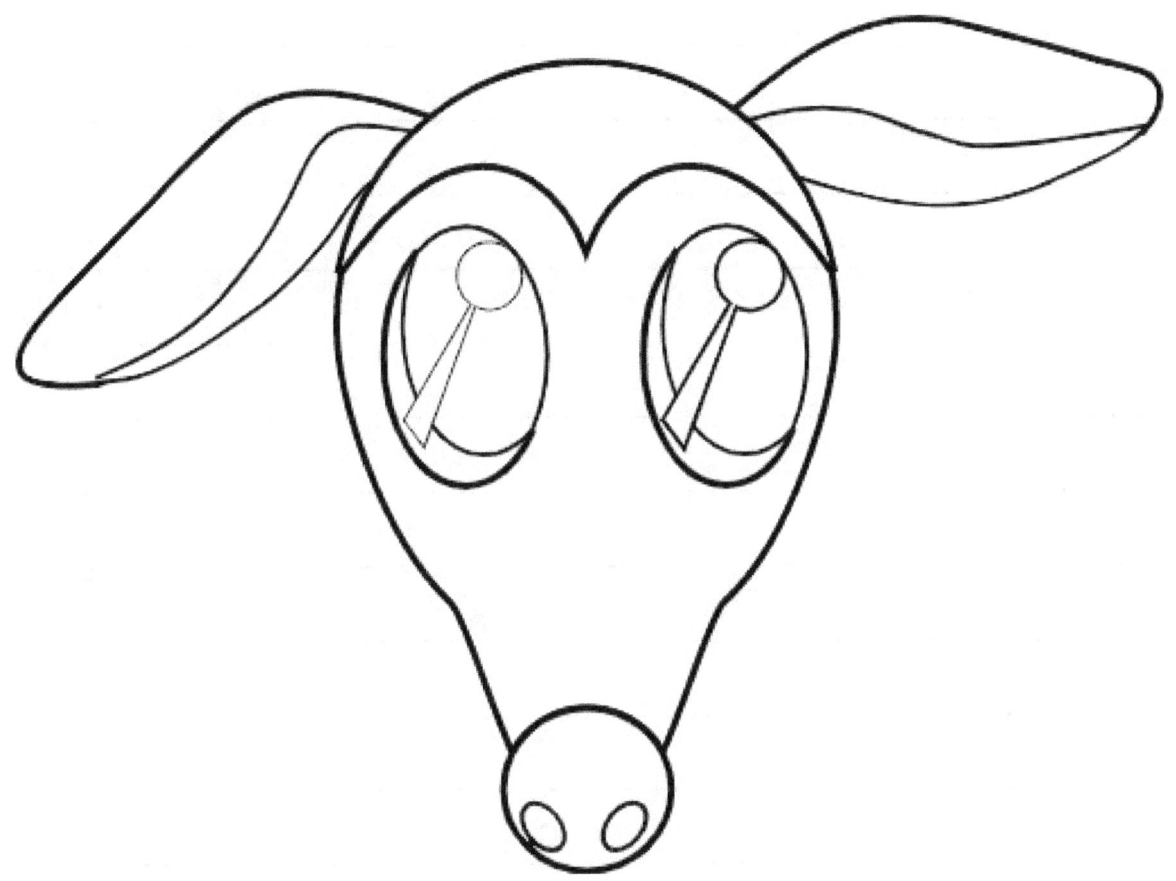

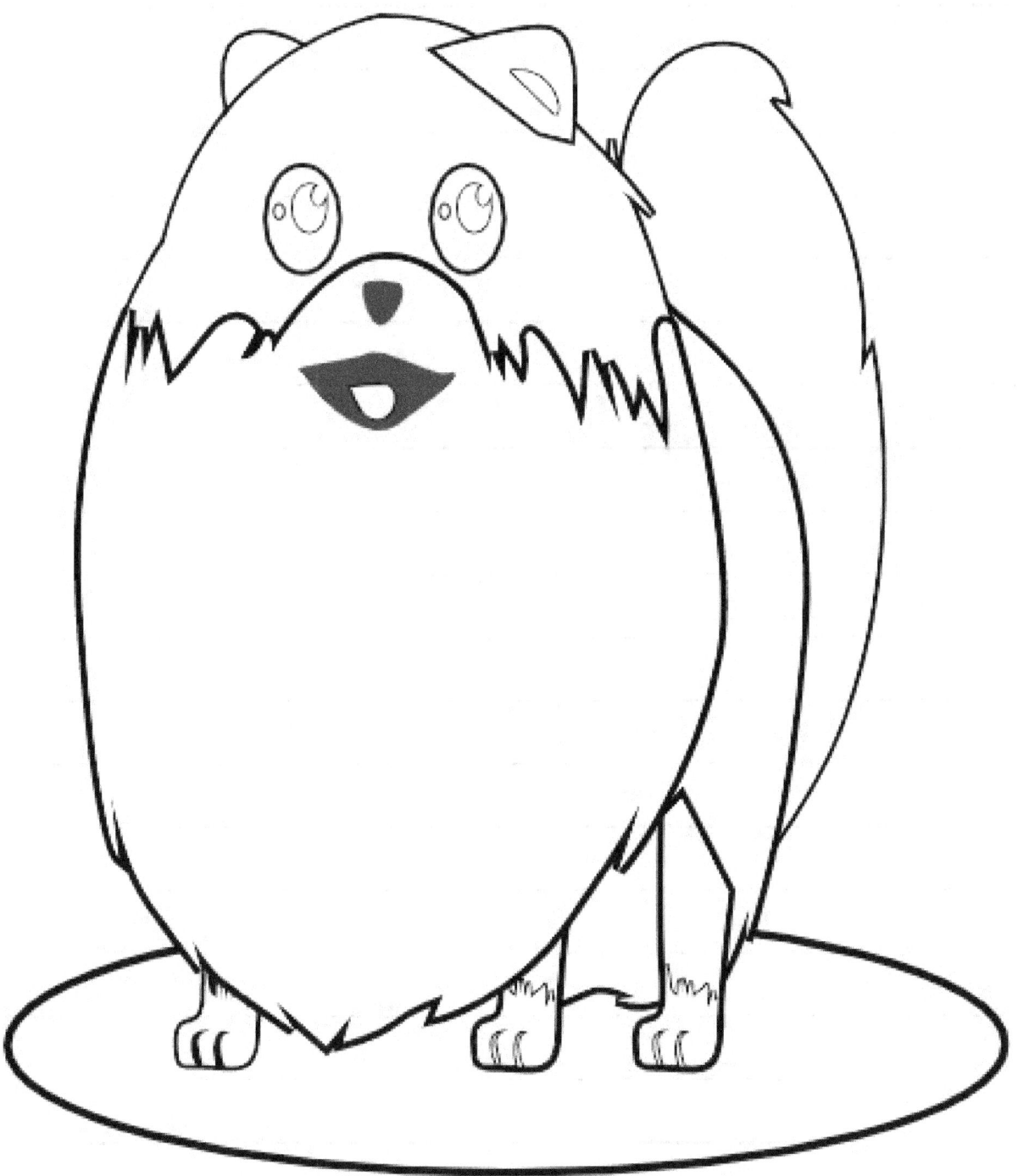

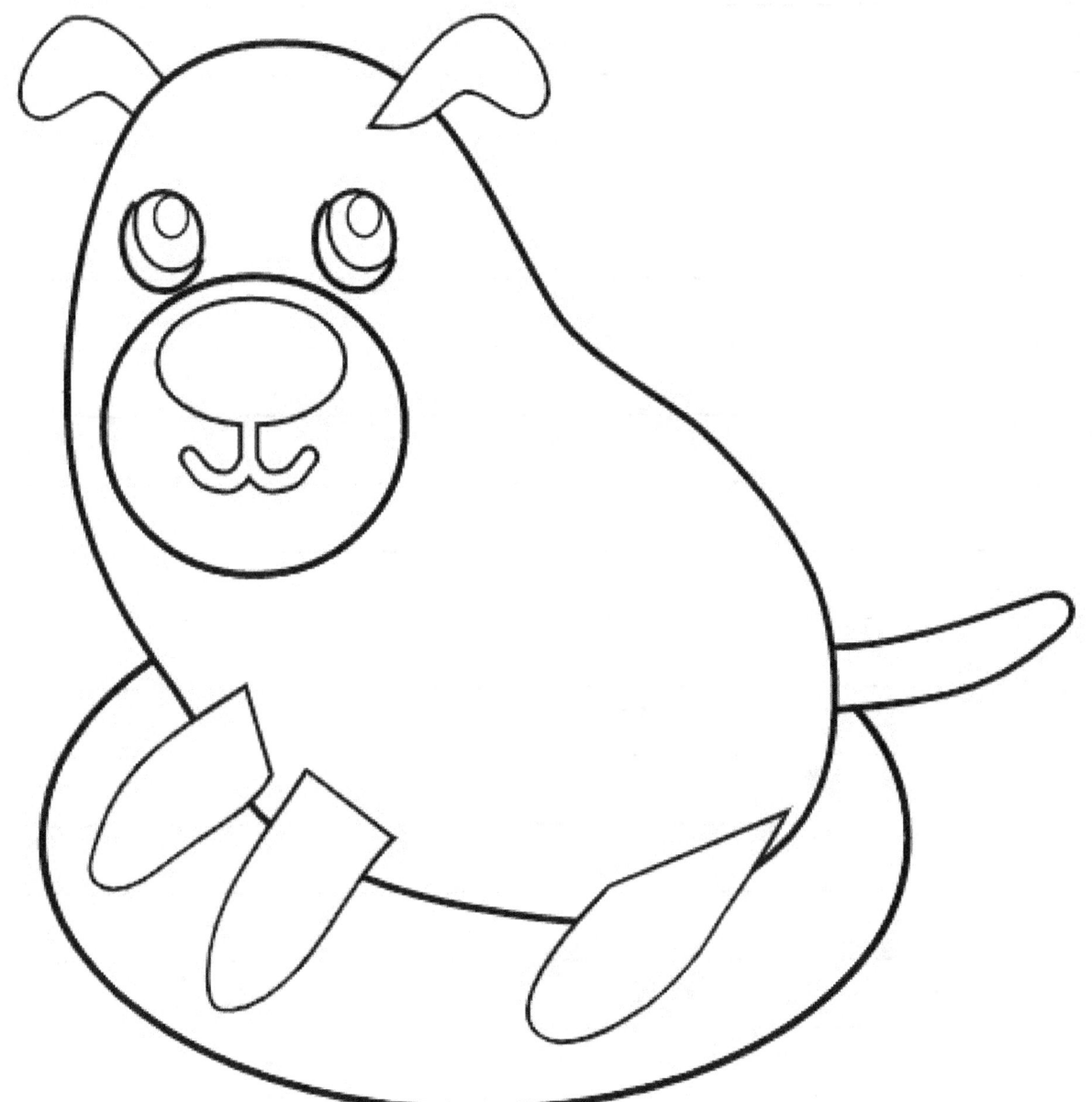

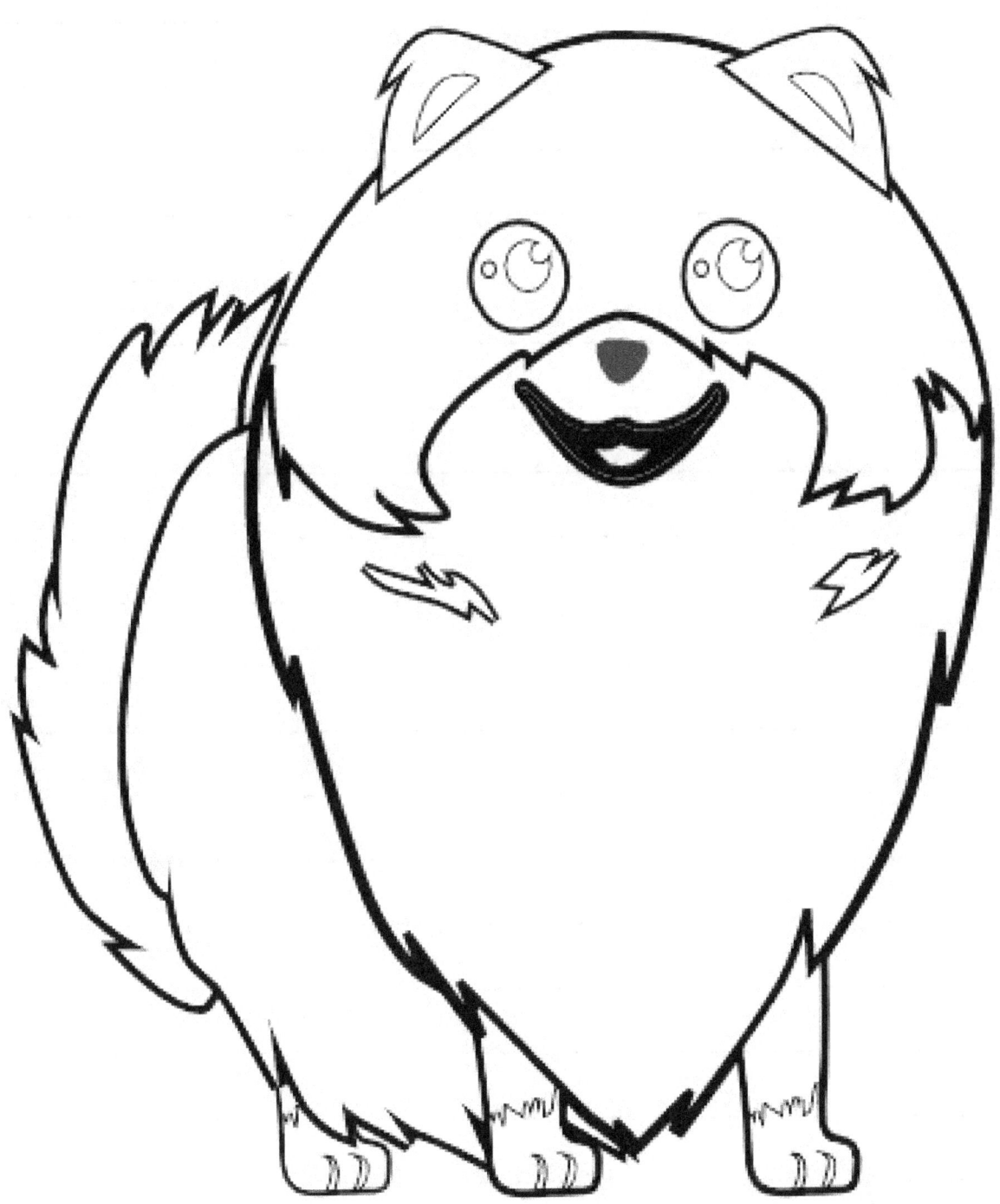

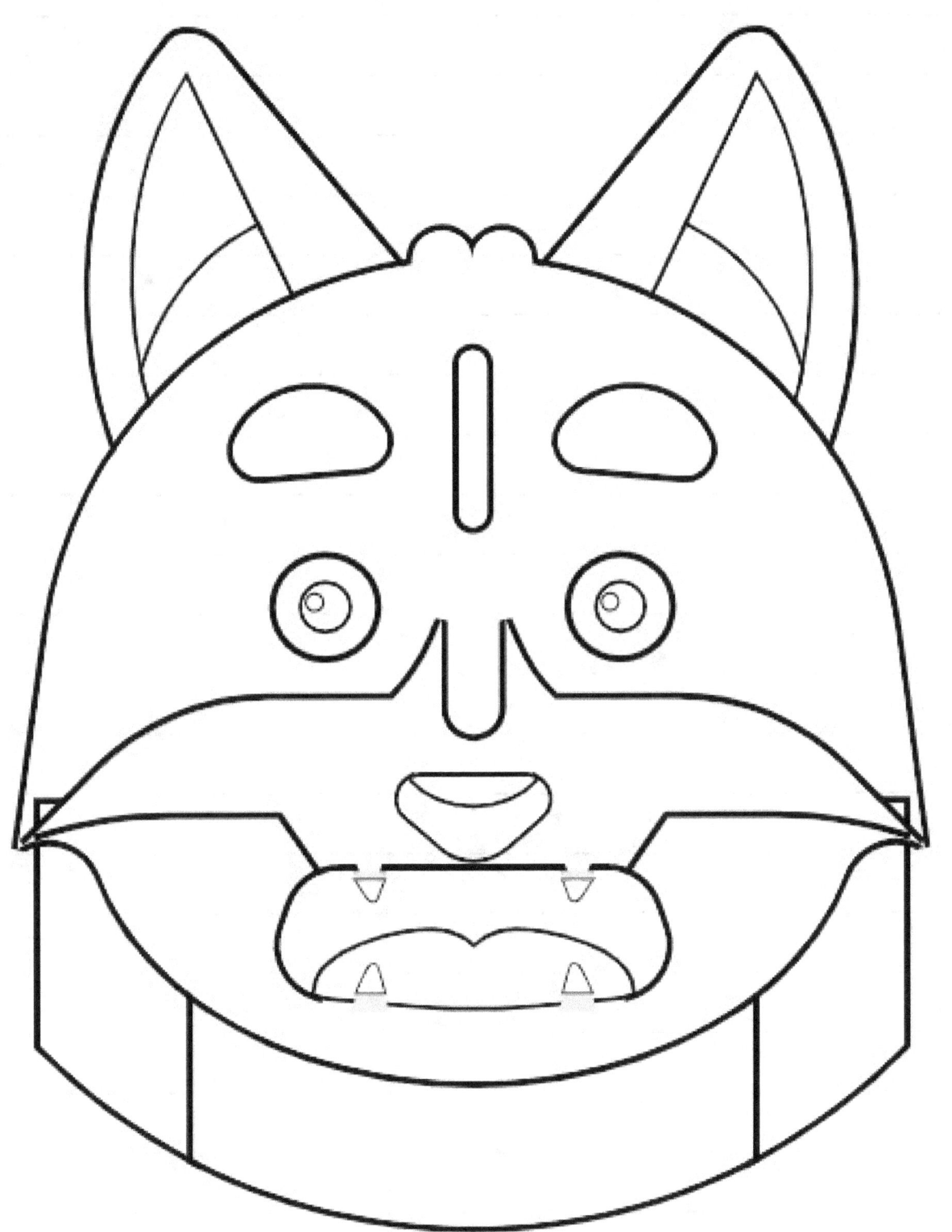

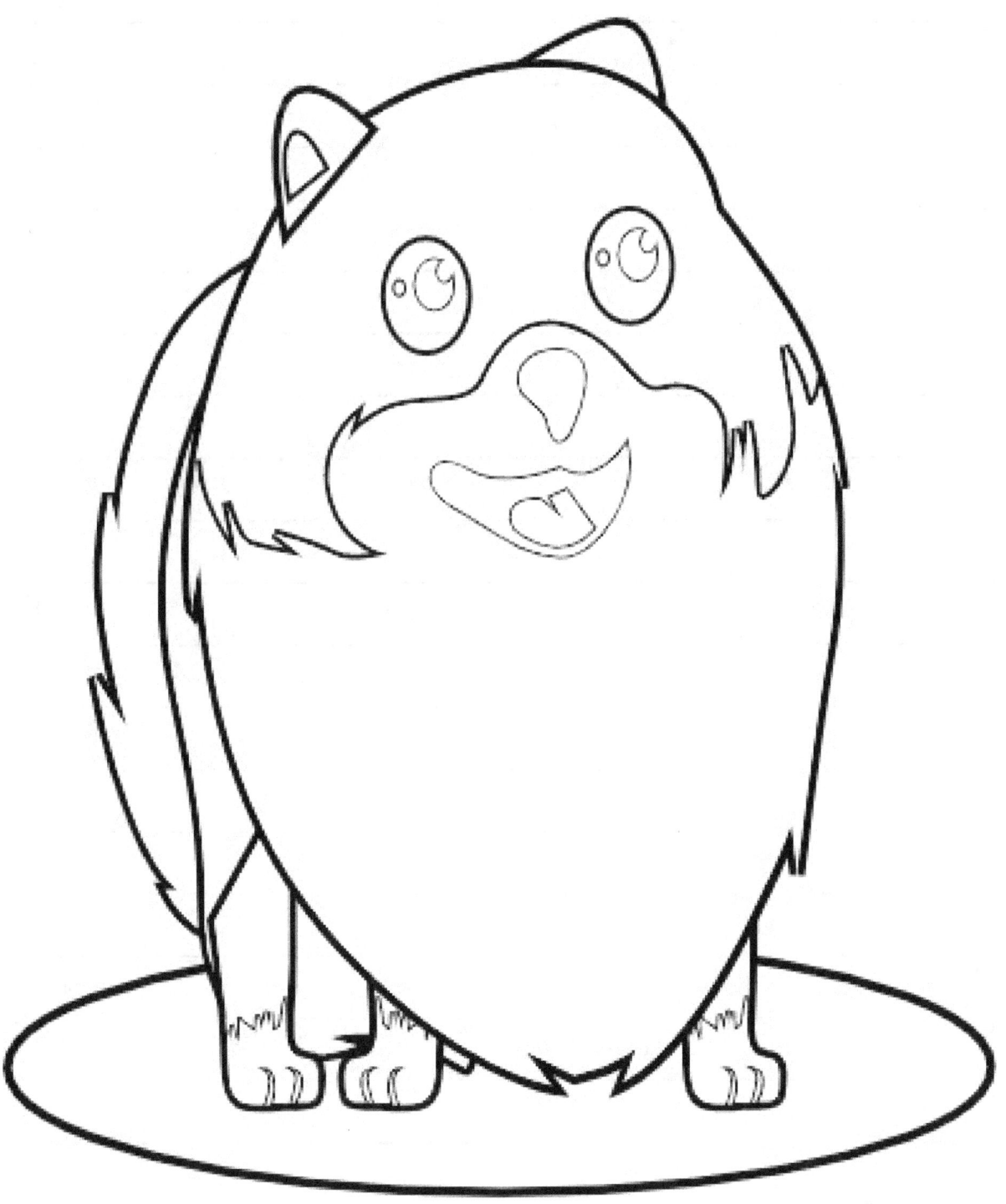

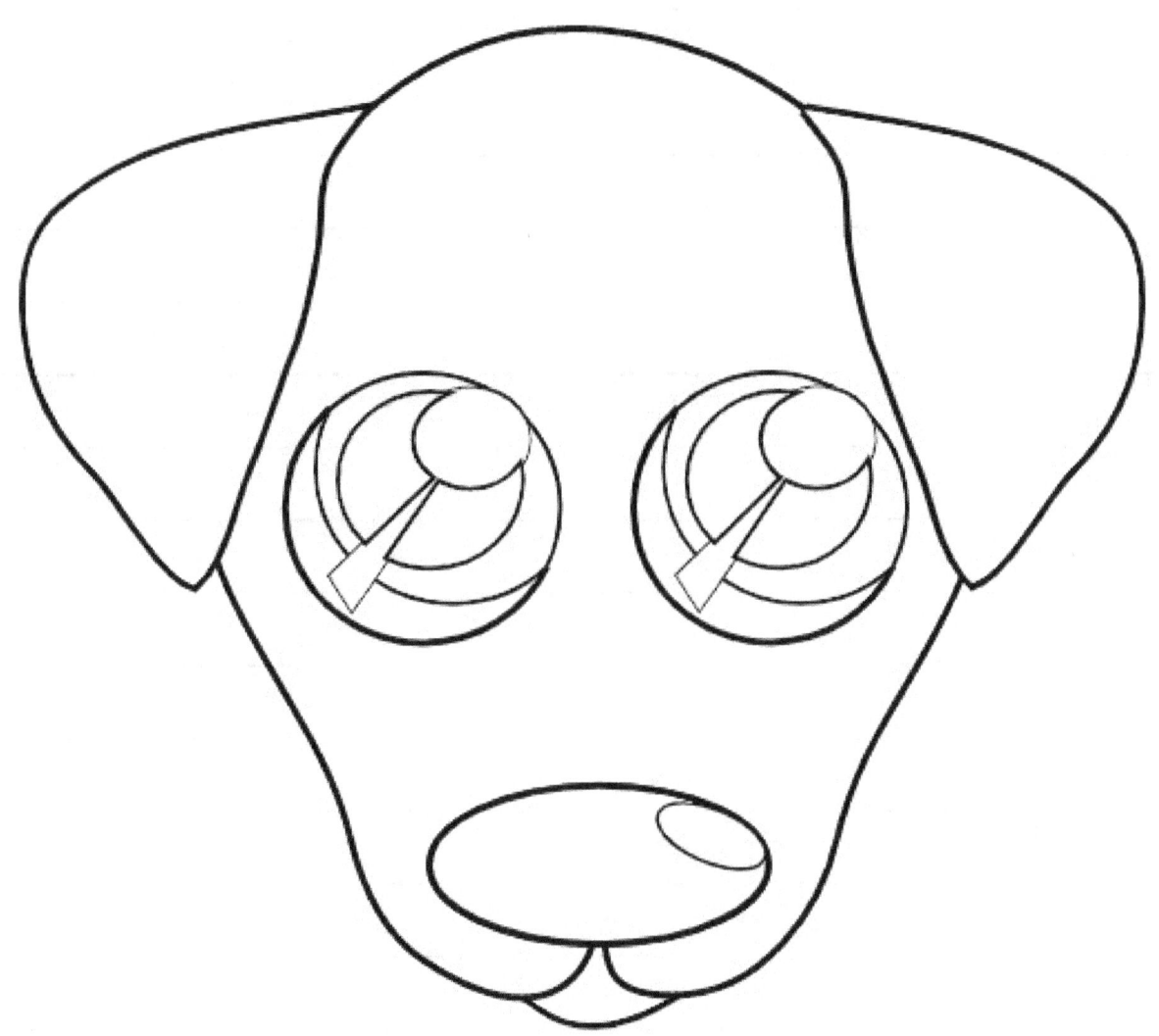

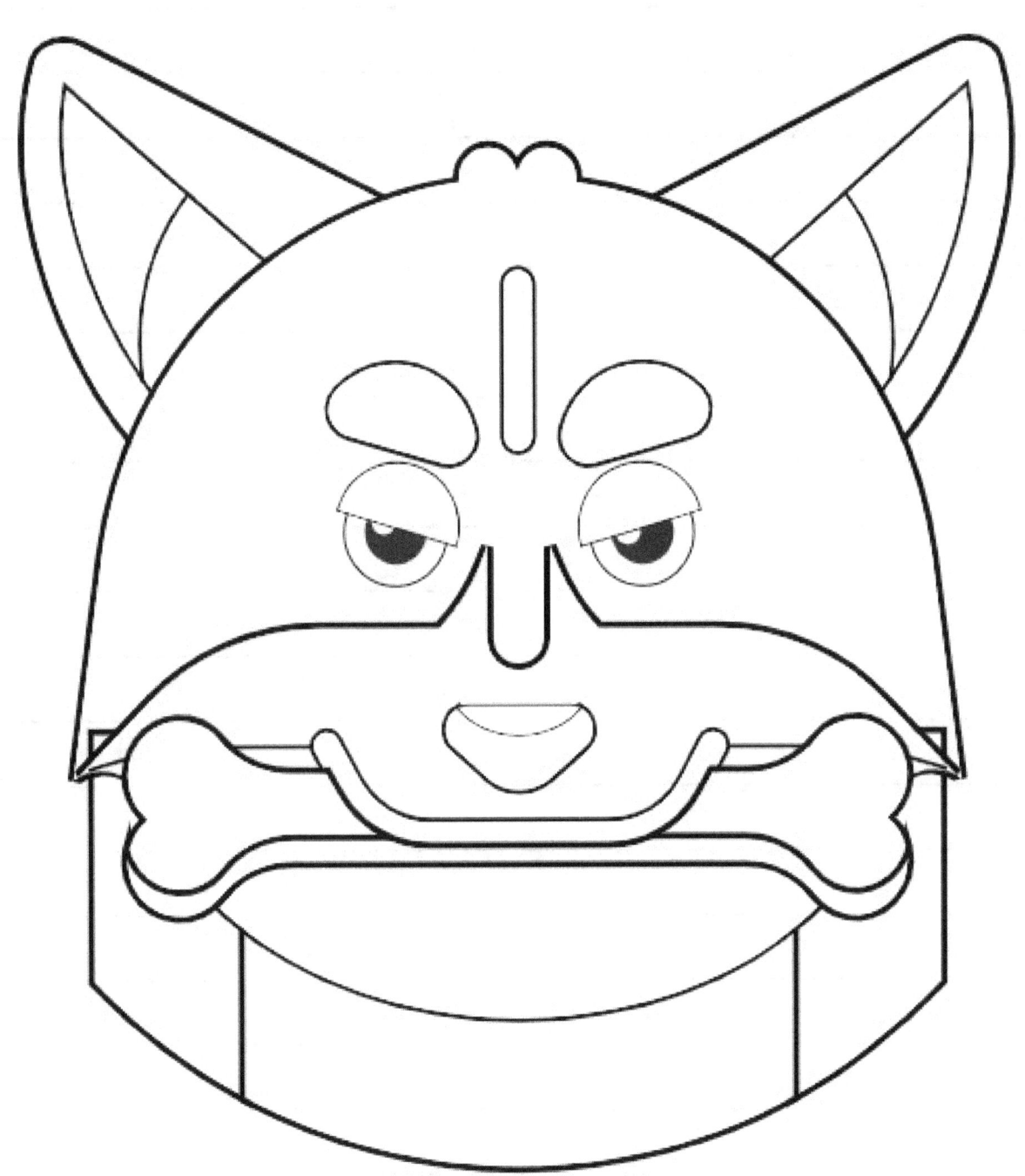

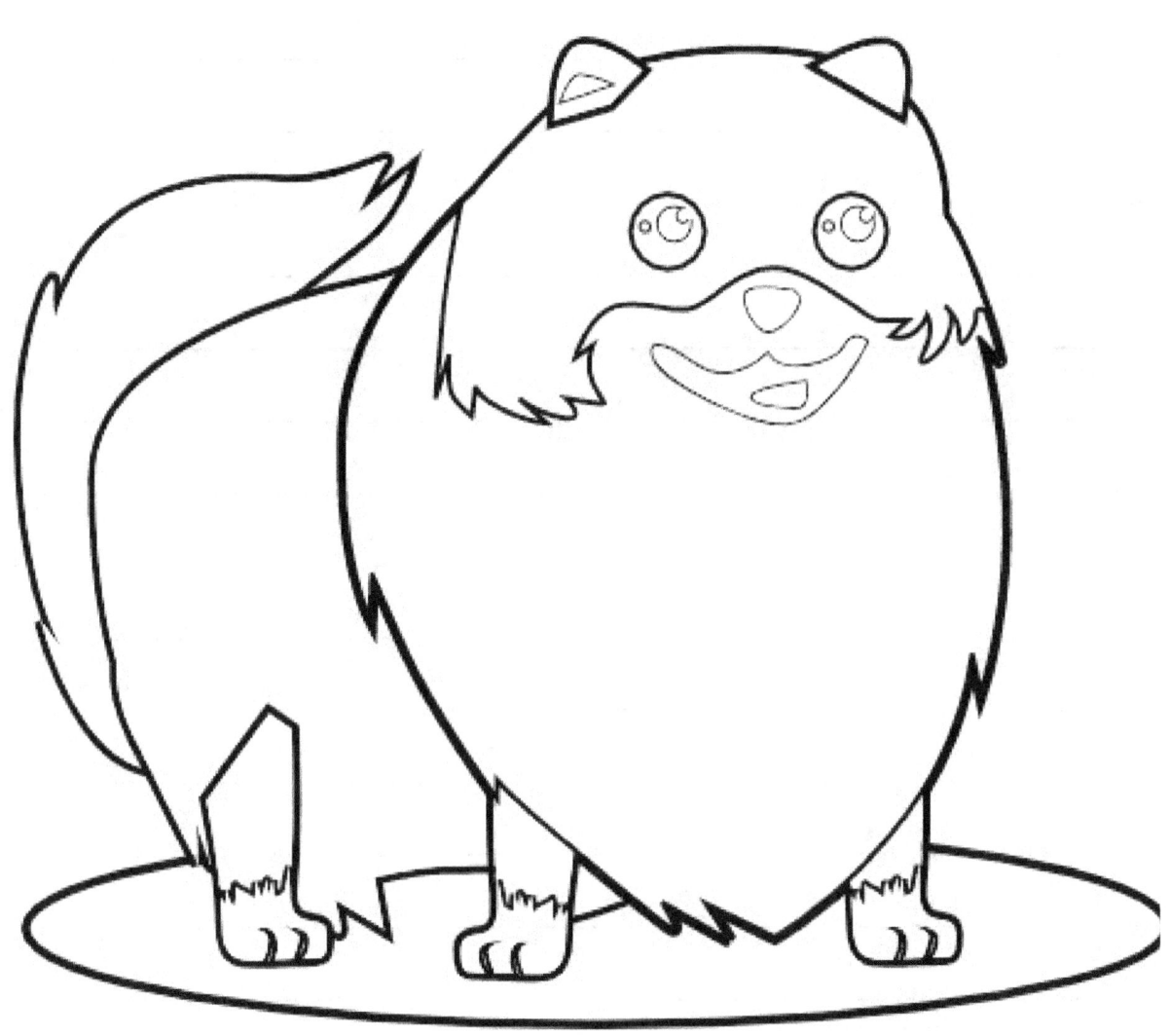

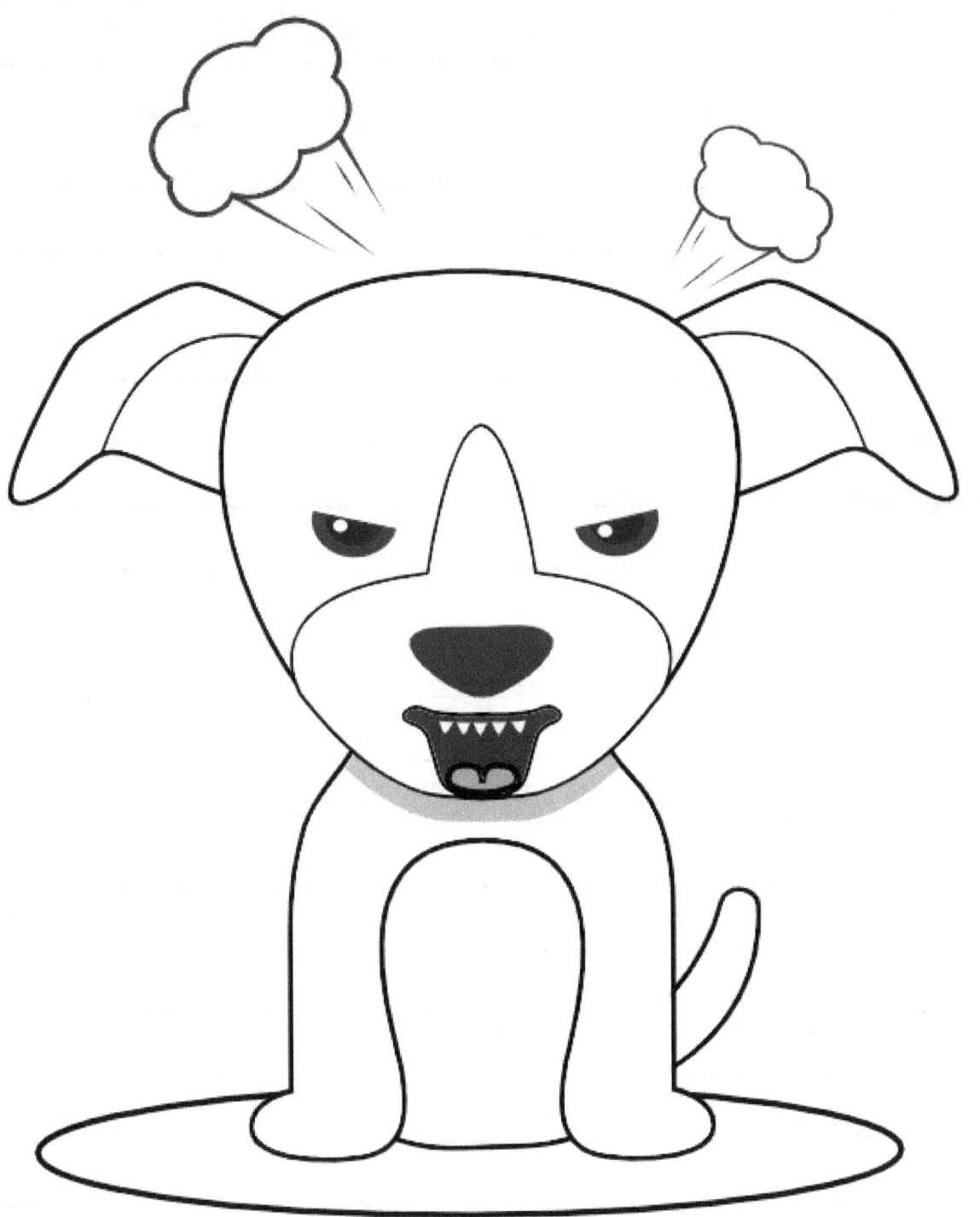

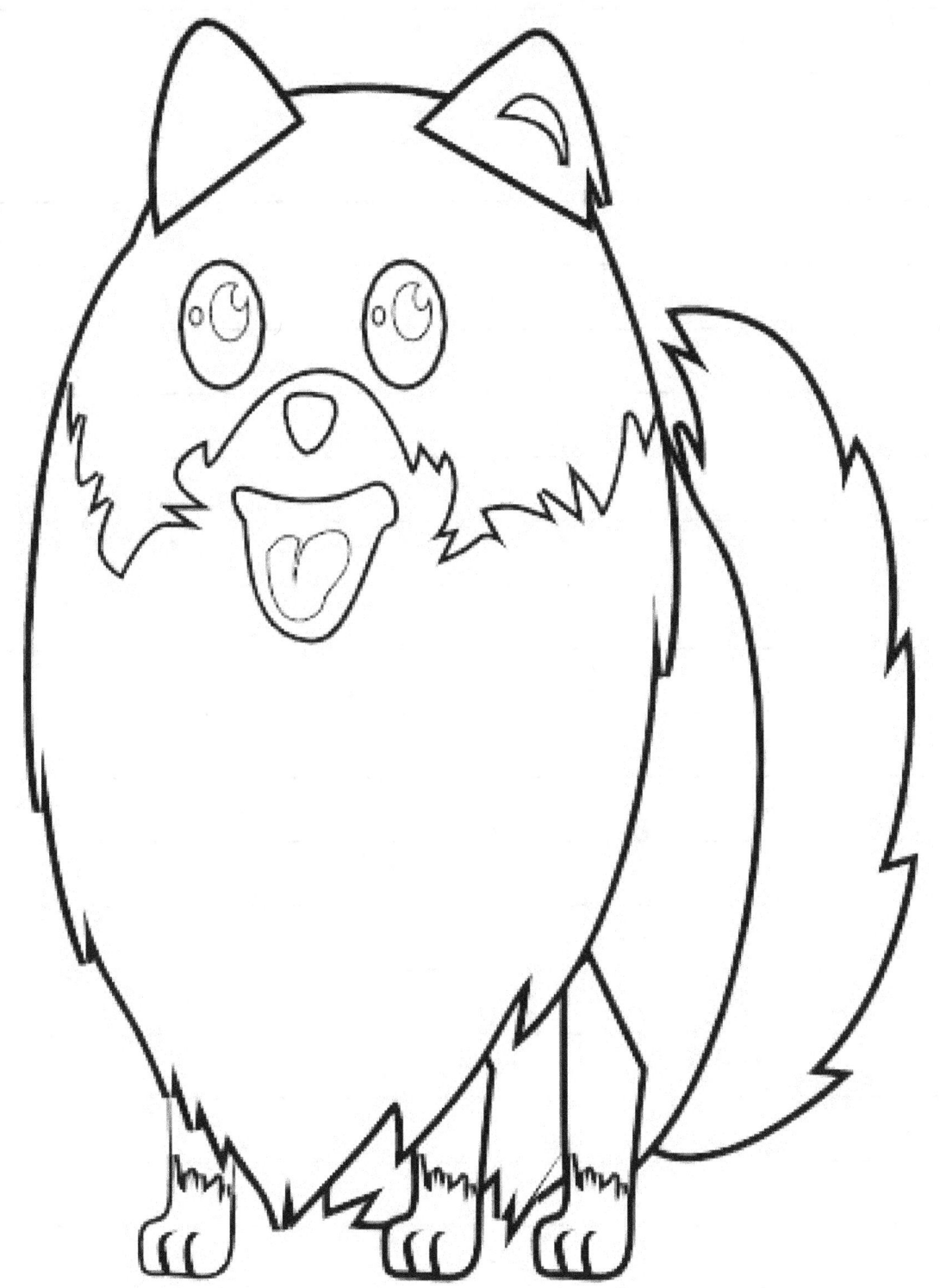

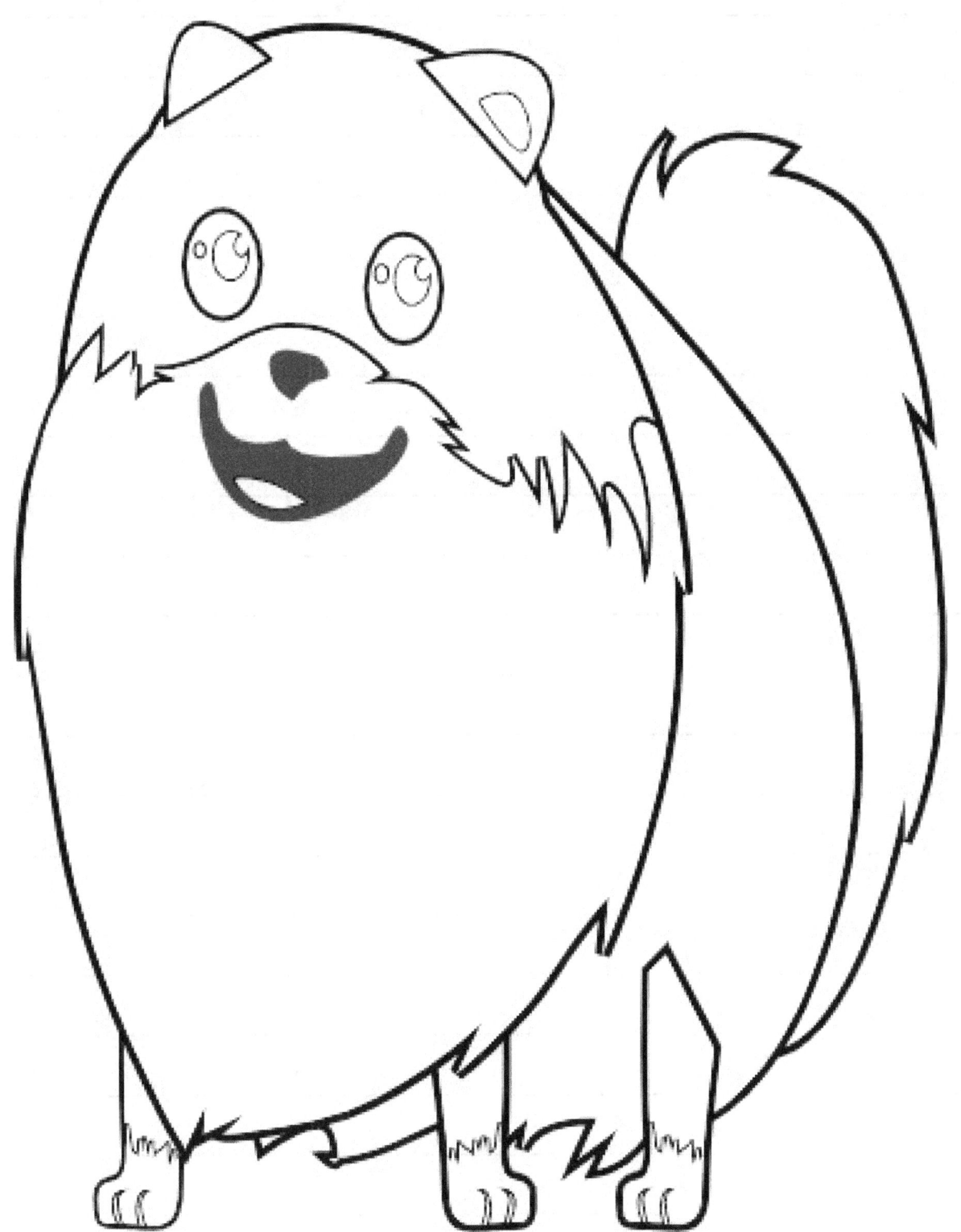

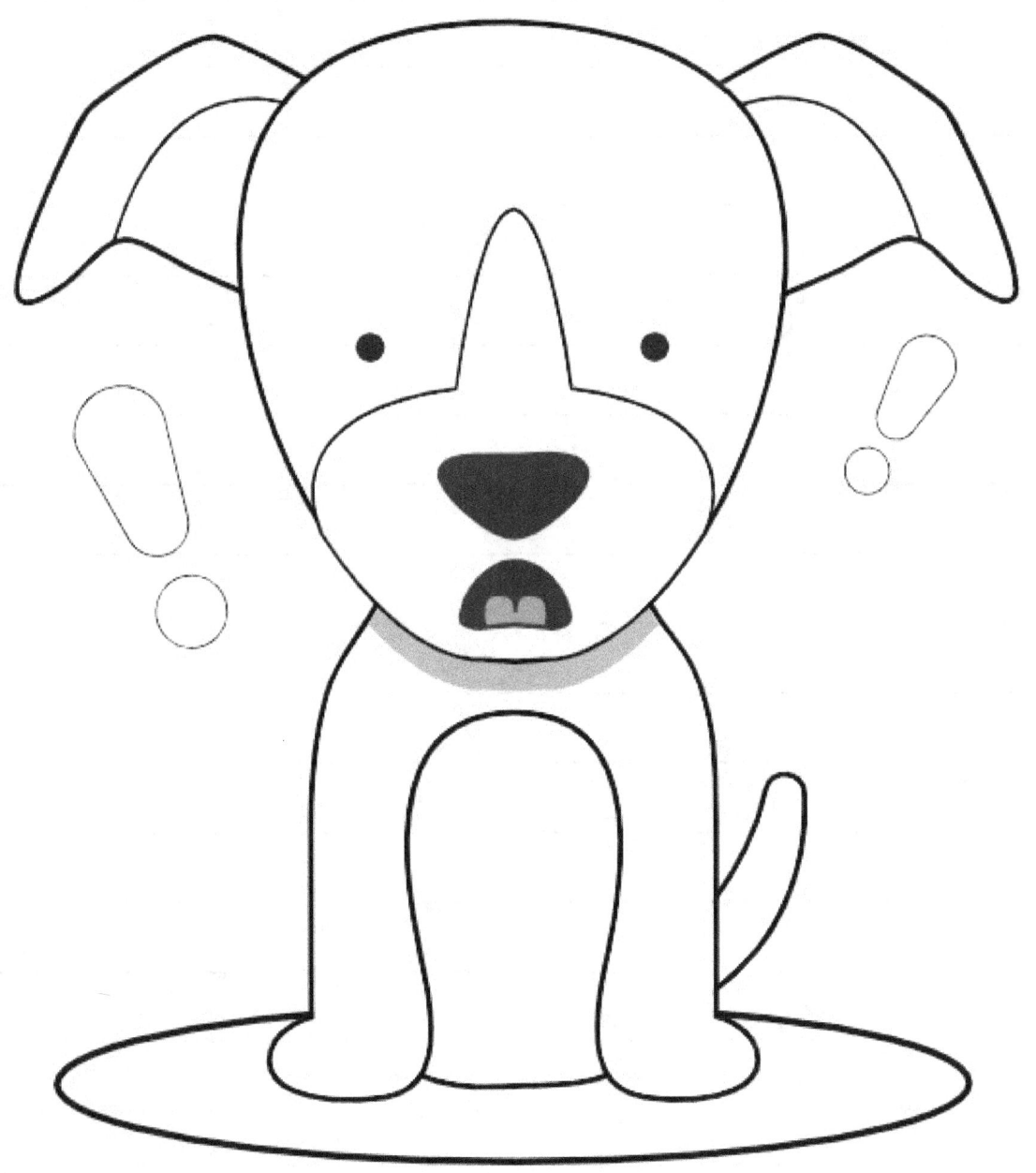

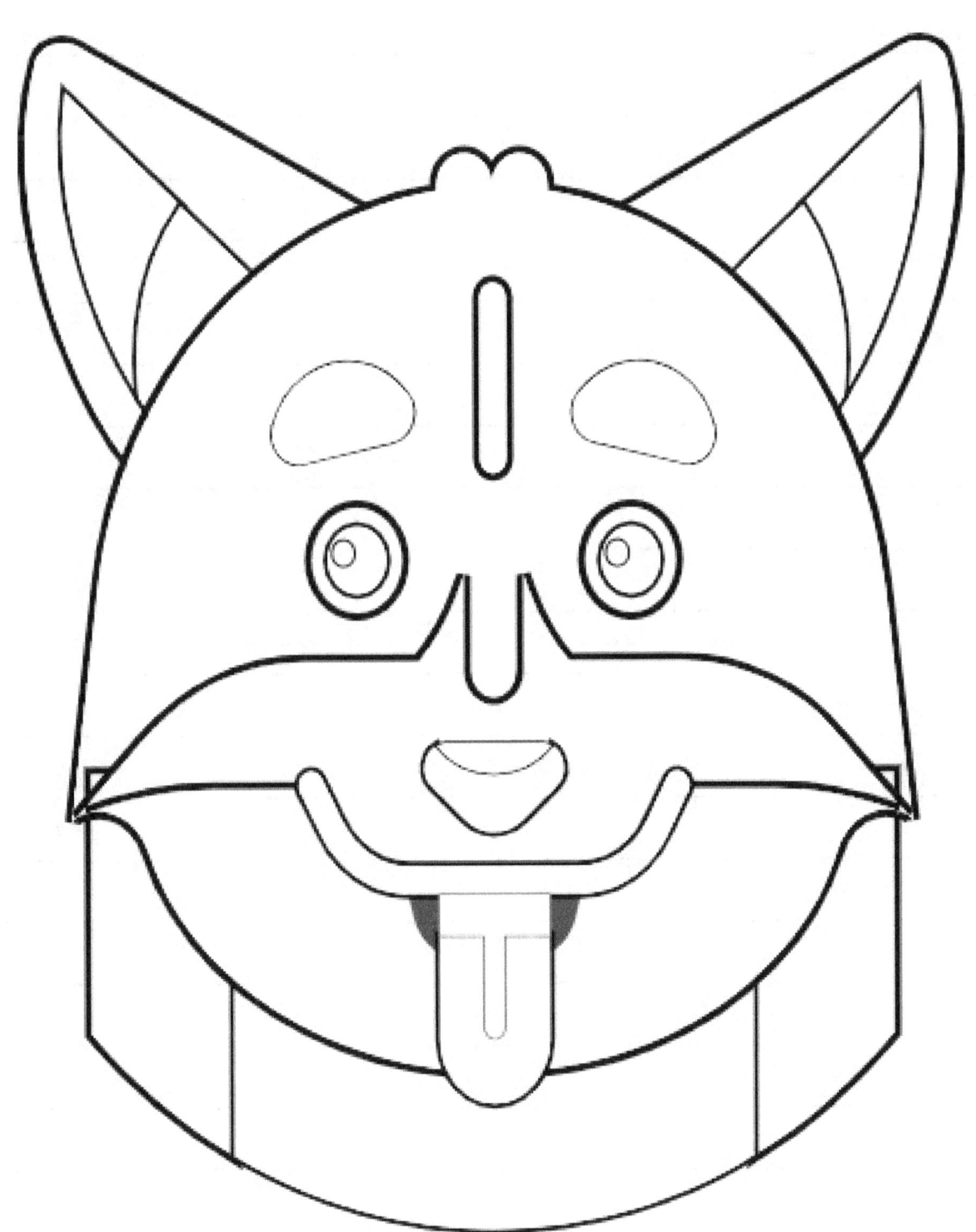

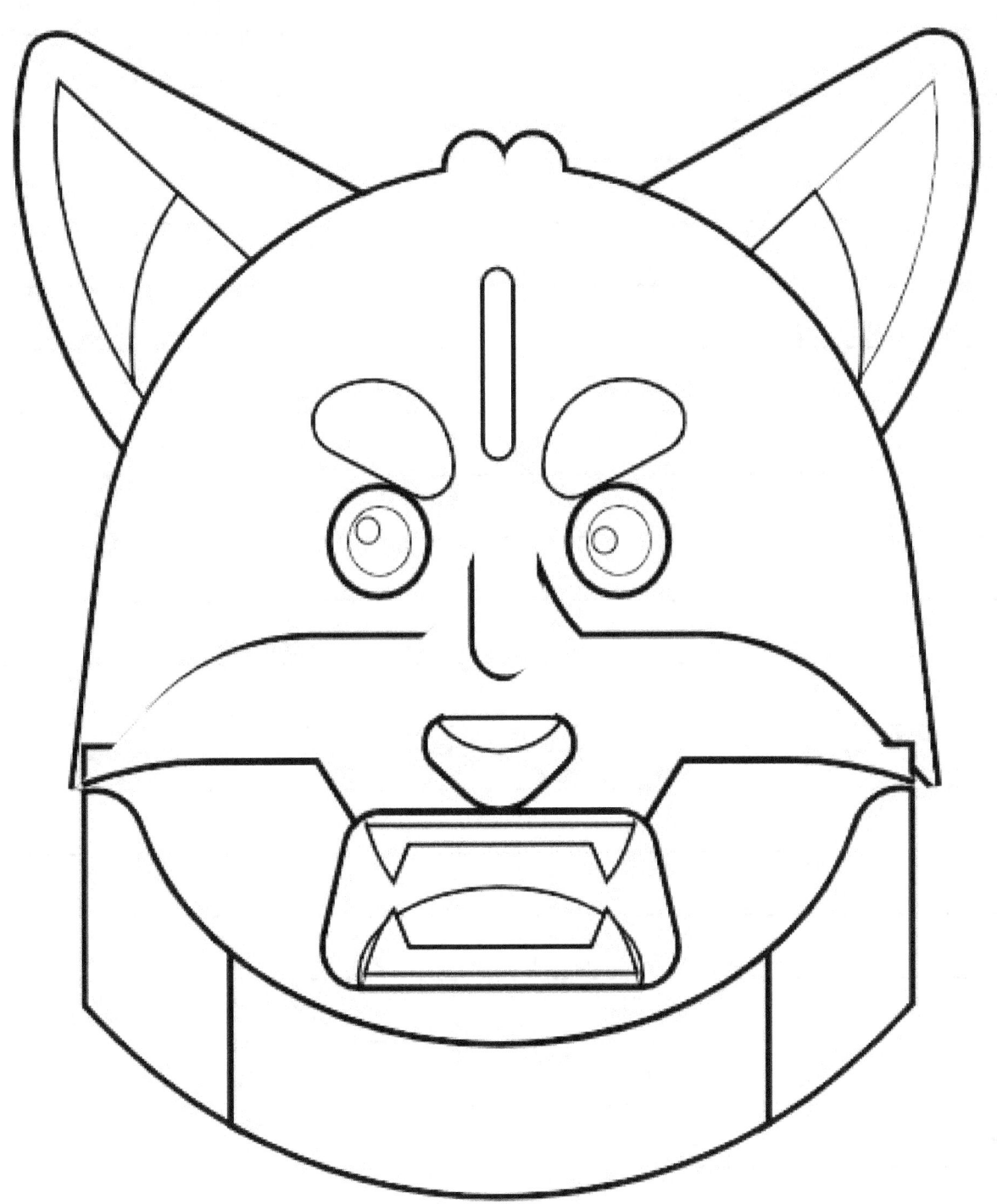

My favorite puppy is
